AESTHETIC REALISM:
WE HAVE BEEN THERE

AESTHETIC REALISM: WE HAVE BEEN THERE

Six Artists on the Siegel Theory of Opposites

TED VAN GRIETHUYSEN
DOROTHY KOPPELMAN
DAVID BERNSTEIN
CHAIM KOPPELMAN
LOU BERNSTEIN
ANNE FIELDING

Definition Press • New York

Library of Congress Catalog Card Number 69–17523
Standard Book Number 910492-11-5

Second Printing, 1970

Manufactured in the United States of America
By The Colonial Press

Contents

Illustrations

EDITOR'S NOTE: The material in this book was originally presented at the Terrain Gallery in New York City on November 18, 1967.

Frontispiece: The paternal estate, where we were carefully instructed in our earliest youth in our holy religion and in the languages of the ancients.

Some Comment
and Background

SHELDON KRANZ

Sheldon Kranz is a poet and senior editor with one of the major publishing houses in New York. He did his undergraduate work at Brooklyn College, and received his M.A. from the University of Iowa, where he attended the Creative Writer's Workshop under Paul Engle. His poems and short stories have been published in magazines both here and in England.

OUR BOOK is called *Aesthetic Realism: We Have Been There* because six artists in the fields of painting, acting, and photography will show the value and technical relevance of Aesthetic Realism in their work. Eli Siegel, the founder and teacher of the philosophy, says: "The world, art, and self explain each other: each is the aesthetic oneness of opposites." What this means will be demonstrated by each artist in terms of the craft he knows and the emotions he has had.

1

Conviction has not come easily to the persons who see a permanent value in this point of view. Aesthetic Realism has had to combat the skeptic and the cynic in everyone. It has had to combat the snobbishness of the art world, the literary world, and the academic world. But for those of us who have tested Aesthetic Realism, it has stood up. We have found that this way of seeing the world, art, and the self is valid and useful; and many of Siegel's students now teaching in colleges and universities use this point of view as their critical method.

Aesthetic Realism means what its name implies: that the structure of reality is aesthetic. Since the 1940's, Eli Siegel has shown through, literally, thousands of examples that all beauty is the making one of the permanent opposites in reality. Further, Siegel is the first person to demonstrate the practicality of and necessity for the aesthetic criticism of self: he has shown that it is the making one of opposites which every person is going after in his life.

Since it has been pointed out at various times that the reconciliation of opposites is not a new idea and goes back to the Greek cosmologists, a little history is in order here.

In 1955, the Terrain Gallery opened in New York City, presenting exhibitions of paintings, sculpture,

graphics, and photography, organized from the viewpoint of Aesthetic Realism. There were shows with such titles as *Design into Emotion, Definition Is Wonder, Personal & Impersonal.* In the same year, the Terrain brought out its first publication—a broadside by Eli Siegel called *Is Beauty the Making One of Opposites?* This was later reprinted in the *Journal of Aesthetics and Art Criticism.*

In the next few years, this broadside and dozens of catalogues of exhibitions describing how the opposites in reality are present centrally in art became part of the cultural scene of New York. In the 1950's, as Terrain Gallery director Dorothy Koppelman can tell you, you were not supposed to define beauty; art was supposed to speak for itself. Everyone read this broadside and these catalogues; nobody outside the Terrain Gallery discussed the ideas critically in public.

But gradually—and one can go to the back issues of the art columns and art magazines to check this— gradually something new began to happen to art criticism. Opposites began noticeably to be mentioned in art discussions. Opposites—sometimes called contraries, sometimes called polarities—began to be seen as important in analyzing the success or failure of a work of art. One article in *Art News* was called "Deliberate Contraries." But no mention was made of Aesthetic Realism, Eli Siegel, or the Siegel Theory of

Opposites, which everyone was aware of and which some artists had been discussing on Terrain Gallery programs since 1955.

When challenged, art editors replied that the opposites were common knowledge. They were attributed to Heraclitus, Aristotle, Kant, Hegel, the Eastern philosophies, and even Martin Buber. The question that wasn't asked and was carefully avoided was this: How was it, if the Greeks and Hegel, not to mention Lao Tse, had written all about the opposites, how was it that it wasn't until after 1955 and the advent of Aesthetic Realism and the Terrain Gallery that the art world began consciously using the opposites as a critical method?

It happens that the way Aesthetic Realism sees the relation of the opposites in reality, in art, and in people is new; and the Terrain Gallery made New York conscious of this. This consciousness has also occurred in relation to the other arts.

This book is an affirmation by six artists of the value of the Aesthetic Realism of Eli Siegel.

Siegel is perhaps best known as the author of *Hot Afternoons Have Been in Montana: Poems*, which was nominated for a National Book Award in 1958. William Carlos Williams, in the introduction to this book, said of the title poem:

I say definitely that that single poem, out of a thousand others written in the past quarter century, secures our place in the cultural world.

Williams continues:

I can't tell you how important Siegel's work is in the light of my present understanding of the modern poem. The evidence is technical, but it comes out at the non-technical level as either great pleasure to the beholder, a deeper taking of the breath, a feeling of cleanliness, which is the sign of the truly new.

Siegel's work as poet has been praised by Dudley Fitts, Karl Shapiro, Kenneth Rexroth, Selden Rodman, Hugh Kenner, and others in such journals as the *New York Times*, *The Saturday Review*, and *Poetry*. But Siegel's equally important prose work, his work as a philosopher and as a teacher of great power and originality, is hardly known. His whole work represents America at its best. Now more than ever it needs what he has to say.

I Believe This About Acting

TED VAN GRIETHUYSEN

Ted van Griethuysen is a graduate of the University of Texas and attended the London Academy in England on a Fulbright grant. He later did graduate work at Yale, and last year was on the faculty of the Graduate School of Acting at Columbia University. With many credits on and off-Broadway and in television, he has also appeared with both the American and New York Shakespeare Festivals. In recent seasons, Mr. van Griethuysen has been seen on Broadway in John Osborne's Inadmissible Evidence *and in Bertolt Brecht's* Galileo, *and off-Broadway in Harold Pinter's* The Basement. *He is a member of the original cast of Eli Siegel's* Shakespeare's Hamlet: Revisited, *and is Artistic Director of the Opposites Company.*

This paper was published in *Drama Critique*, Spring 1968.

I BELIEVE that acting is the making one of opposites. This is the *art* of the art I know. Craft and beauty, technique and wonder, are the same thing here. Craft and technique accent the process; beauty and wonder accent the end result. I have learned this from Aesthetic Realism. It was taught me by Eli Siegel; and I have seen it for myself.

I first heard the Aesthetic Realism approach to acting formally presented in a lesson that Anne Fielding and I had in 1961 with Mr. Siegel. He said:

> If Aesthetic Realism is correct, everything that happens in a play is illuminated, or at least has something said of it, by the opposites. I should like this to be put to the test. Acting is a certain way of taking the contraries of the world.

Acting to me means characterization: you become the part. And I believe that characterization, in every instance, is putting together yourself and the part, yourself and something other than yourself. I believe that opposites explain how to do this in the best way.

1. SAMENESS AND DIFFERENCE

In teaching acting, there are two questions I give as the basic approach to all characters: How is the character the *same* as yourself? How is he *different?*

One never gets away from this. All acting is going after the successful oneness of self and role as the same and different simultaneously. You become the role, even as you remain apart from it.

We begin as different from the character. Then there is some rapport, some similarity, and the fundamental similarity is this: we are both individual selves. Each of us is a Me. We both exist in the whole world, and we both have to do with particular people, places, and things—all in the same world. Rehearsal and performance are the process of finding ever more precise points of sameness and difference—identification and characterization.

To give an example:—One of the performances I've given that has pleased me most was my last performance of Troilus in *Troilus and Cressida* at the American Shakespeare Festival. During the run, I tried to find the right way of playing the final scenes in which Troilus is vigorously and variously angry. To show anger onstage has never been easy for me. It is not an easy emotion for most actors. I tend either to silent, suppressed rage, or to anger of the stiff, noble variety. Neither of these worked well for Troilus. Still, we had anger in common.

My mistake had been to see Troilus as too noble, too heroic in order to accommodate his emotion more comfortably to myself. As I came to know him bet-

ter, however, I found that he is not a noble young hero. He is somewhat spoiled and bored. He does not care much for himself, really, nor does he have any great liking for the world. How much he actually loves Cressida, or she him, is open to question. They are not like Romeo and Juliet. When Troilus believes that Cressida has been untrue to him, he changes immediately from sultry love sickness to disgusted fury. He relishes his anger. When his brother Hector is killed by Achilles, he wants to let go and tell off the world. It is the kind of anger most of us can feel but rarely show, and certainly not in iambic pentameter. It isn't fine, noble anger. We don't particularly admire it; but we do recognize it. I saw that Troilus's anger was much closer to an anger of my own than I knew, though to be sure the circumstances of our lives are very different.

This gave me the lever I needed. In the last performance, for the first time in my work, I knew I had expressed a fine and precise rage. Instead of feeling drained, I felt exhilarated.

In Eli Siegel's poem, "Ralph Isham, 1753 and Later," there are two lines that have stayed with me and are in my mind as I approach every character I play:

> What was he to himself?
> There, there is something.

One tends to be skimpy in dealing with likeness and difference, to come to premature, easy solutions. Too much one tends to play one's impression of the part, rather than the part itself. The hardest thing is to see an inner life to the character that is as rich, as real, as puzzling, and perhaps as painful as one's own. How much inner life do we grant to other people? Very little; and actors approaching a character find it hard to give much more than that. Nor is it easy to distinguish between true inner life and something made up, hastily assembled from inadequate knowledge.

Siegel's question—"What was he to himself?"—put this problem in a different light for me. I'd never thought of it in just that way. I had asked: Who is he? What do I think of him? What does he feel? But that is not quite the same as "What was he to himself?"

2. INTERNAL AND EXTERNAL

Acting is the making one of internal and external. Everything the actor does externally is for the purpose of making seen the internal or unseen. The use he makes of his body and voice, his make-up, costume, and properties—these are his means of bringing opposites together. This is how he makes feeling and thought visible, the abstract tangible. This is how he

gives structure to what he sees as freedom of expression; this is the way he gives form to free, unshaped emotion and thought.

Sometimes it is the internal which leads to the right external means. Just as often, something outside the actor makes his internal life coalesce and become clearer to his mind's eye. It may be that one external touch can pull the whole character into shape. This is what happened with Laurence Olivier's green umbrella. Olivier was once playing a character he couldn't get. When the properties arrived, he found a green umbrella among them, and he felt: "Ah, now I know him! Now I know who he is, and I know what to do!"

For me, it is often some element of costume that will give the inner life of the character that last necessary lift. It may be the cut of a suit, the length and weight of a train, the shape of a collar, the feel of gloves. Always I am affected by the kind of shoes I wear. Are there heels? Are the shoes heavy or light? hard or soft leather? Do you walk the floor, do you brush it, do you grip it? How the character meets the earth most constantly through his feet interests me very much.

3. IMPERSONAL AND PERSONAL

One of the oldest debates in acting is represented by Stanislavski, on the one hand, who said: "In our

art you must live the part every moment you are playing it, and every time"—and by the French actor, Coquelin, on the other, who said: "I am convinced that one can only be a great actor on condition of complete self-mastery and ability to express feelings which are not experienced, which may never be experienced, which from the very nature of things never can be experienced." It is the big question: Do you actually feel what the character feels, or do you only give the appearance of doing so?

Siegel, in a 1951 lecture, defines acting in terms of feeling—as "the known showing of another feeling than you, as you see yourself, are disposed to have. By this I mean that all acting is conscious." This puts together Stanislavski and Coquelin. It shows that there is a simultaneity of subjective and objective, personal and impersonal. It answers the debated question. Yes, you do have the feeling of the character, but not the way the character himself has it. He has the feeling; he is not consciously showing the feeling of another.

What happens can be better seen through another short statement from the Aesthetic Realism acting lesson of 1961. Siegel said: "A character consists of two things: (1) a quality that is permanent, and (2) a specific example of the permanence."

A character has a feeling. Troilus, for example, has

anger. He knows he has it, and he has some idea of why and about what. The actor sees that Troilus has anger. At the same time, he knows that anger is a permanent thing in people. Then he sees that it is in himself, as actor-self, and it is in the character. He sees the emotion as both permanent and particular, impersonal and personal. To the degree to which he understands the character's feeling—gets inside it— that much he experiences it. When the universal is seen in the particular, the impersonal in the personal, the actor has an emotion which both propels and gives shape to the emotion of the character.

4. RESPECT AND CONTEMPT

I believe that the chief obstacle, the principal impediment, restriction, hindrance to full expressive freedom in the actor is *contempt*, in any of its various forms: indifference, laziness, snobbishness, competition, jealousy, mechanicalness, ignorance, inarticulateness. It is that in the actor which interferes with the best and most efficient oneness of the part and himself; it is the big cause of trouble between the individual and the ensemble.

This is inherent in Stanislavski's books. He says: "The very worst fact is that clichés will fill up every empty spot in a role, which is not already solid with living feeling." He warns against "a conscious princi-

ple which is far from easy to change or root out of the artist—the exploitation of art."

Michael Chekhov, in *To the Actor*, is intense about the tendency in the actor to accumulate "garbage" in his mind. That there are things in the actor which impede him is known. But that contempt is the source of that impediment has not been previously seen. Siegel describes contempt this way: "There is a disposition in every person to think he will be for himself by making less of the outside world."

I believe that every actor has contempt and respect in his mind as two purposes and two values. There will likely be some fight between them always. The answer to this fight is to know more and more about it; and the best way to know more and more about it is through Aesthetic Realism criticism.

I believe that Aesthetic Realism criticism is needed by an actor all his working life. I have had this criticism, and it is my most valuable tool as an actor and as a teacher of acting.

5. "YOU BECOME IT"

There is a feeling—and I once had it—that actors are born, not made. You either have it or you don't. Acting can't really be taught. I would not be teaching now, however, if I had not seen that, with Aesthetic Realism as the basis of one's approach, the art of act-

ing can be taught in a way that has not previously been thought possible.

It is thanks to the original work of Eli Siegel that this is so. Siegel is primarily concerned with a way of seeing the world, but he has an important place in the history of the theatre as thought, and in the development of the art of acting as beginning with thought and with the mind of the actor.

I close with an excerpt near the end of the acting lesson. This is Aesthetic Realism looking at acting with the utter simplicity and charm of the truth:

As soon as you ask yourself what does another person feel, you are taking an expedition, because the only way to feel as that person does is to become that person. The self is multiple and the more exercise it has in being other than itself, the more it comes home refreshed. . . . As soon as the amoeba began to see, it began pretending, because as soon as you are interested in objects, some of the object becomes you, and you become the object, and, in the meantime, you are you. This has to do with people reading novels. Something in us struts and takes the part of the hero, simply by reading about the character. According to Aesthetic Realism, all seeing is an extension of self, a change of self for the purpose of establishing self. You might say that acting is continued seeing, overt seeing, because you show the result of what you saw—you become it.

I Believe This About Painting

DOROTHY KOPPELMAN

Dorothy Koppelman is a painter, teacher, and the director of the Terrain Gallery since 1955. Included in Who's Who in American Art *and* Who's Who in American Women, *she is the winner of a Tiffany grant and her work has appeared in various exhibitions, including those of the Museum of Modern Art and the Brooklyn Museum. Mrs. Koppelman is a member of the faculty of the Adult Education program at Brooklyn College, and was, for a time, art critic for* The Washington Independent.

EVERY PAINTING that has ever existed has something in common with every other painting that has ever existed, and that something is opposites. Further, these opposites are the same as the beginning opposites in reality itself. I believe that Eli Siegel has described the underlying and permanent content of all art and

the purpose of every artist, in his statement: "In reality opposites are one; art shows this."

Without opposites painting would not exist, and all painting can be judged by Eli Siegel's 15 Questions, *Is Beauty the Making One of Opposites?* Take Sameness and Difference:

Does every work of art show the kinship to be found in objects and all realities?—and at the same time the subtle and tremendous difference, the drama of otherness, that one can find among the things of the world?

La Grande Jatte by Georges Seurat has sameness and difference from beginning to end. The people are separate and together; people and animals are close and yet distant; trees and people both have a permanence and yet look casual. The horizontals, diagonals, and verticals of the grass are repeated with variations in the sitting, strolling figures. And there is Seurat's pointillist technique consisting of small, separate dots made of contrasting colors juxtaposed so closely that they blend to make sunlight or shade. Georges Seurat has been called by the critic Leslie Katz "the saint of contrast and the hero of relation" because of the way the painter saw the world, people, and technique itself as a oneness of opposites.

Sameness and difference are just as surely present in this landscape with no people at all by the con-

temporary Roy Lichtenstein. The pop artist also uses dots, but of one color within one area, with a definite space between each dot and a hard separating edge between each area. Seurat's color theory of blending through contrast, and Lichtenstein's optical fusion and dazzle are the same and different. The "kinship" and "drama of otherness" in these two works could be studied for a long time.

In *Still Life with Bread* ascribed to the 17th-century French master, Chardin, the intimate objects have the sameness and difference of the world itself. There is sharpness next to softness, shininess next to dullness, crowdedness near space, open objects and closed objects; and there is, as there was in the Seurat landscape, a relation among objects which makes us feel their uniqueness and their inevitable need for one another in just this arrangement. It is the simultaneous impact of sameness and difference at once that makes this still life quietly magnificent.

A so-called representational painting is good for the same reason an abstraction is good: because of the making one of opposites. All abstraction depends for its vitality on how opposites such as sameness and difference, rest and motion, oneness and manyness are seen, thought about, shown, and composed. Mondrian's *Broadway Boogie-Woogie*, for instance, is a

study of the motions of the world. Yellow stripes go up, down, and across. Yellow is glowing and linear at once. Red and blue rectangles are placed with change and sameness in the yellow bands. There is a tension of energy and repose, sameness and difference which Mondrian himself called "dynamic equilibrium."

Eli Siegel has described happiness as "dynamic tranquillity." In the Mondrian work, as in every good painting, there is that arrangement of beginning forces we want to have in our own lives.

It has been said that when art forms change and new styles appear, we need a new criterion. This is not so. We have always needed a criterion that would be large enough, deep enough, exact enough, and non-egotistical enough to be true to all of what art is. The Siegel Theory of Opposites is that criterion. It is true about the drip paintings of Jackson Pollock and the squares of Josef Albers. The opposites are present now in the paintings of Raphael Soyer at the Whitney and in the sculpture of Picasso at the Museum of Modern Art. The Siegel Theory of Opposites is a criterion for seeing what art comes from, what it is made of, and what its value is, that never fails. Our own perceptions, however, have to keep up with the subtlety of the opposites and their meaning.

I believe that every painting can teach us how to put opposites together in ourselves. In teaching, I

have asked students if there is any relation between the composition of a painting and their own families. Of course not, they say. And then we begin. Is each member of your family part of a whole? Are you part and whole? Do you all have insides and outsides like bottles and boxes? Do you have thoughts and feelings usually unknown to one another; and do each one of you have faces, bodies, and habits, sometimes all too familiar to one another? Do you get angry at each other and also hug each other? We can go on. The point is that the opposing forces in ourselves are like those in other people, in other families, and in the world. In painting, hugging and dislike are composed; part and whole are composed; nearness and distance are composed; known and unknown are composed. I believe that art will be seen sensibly—that is, as a necessity—when the relation between what art has and what we want, as it is described by Aesthetic Realism, is studied and understood.

I believe that all art arises out of gratitude, a deep pervasive feeling that you are glad something exists outside you and that something can complete you. If an artist doesn't say, "Thank God you exist" to any object he is looking at, he will miss the essence and skimp the job.

Every artist has to have, as part of his beginning

equipment, a desire to be just to what is not himself. Every artist is proud to need the brush he uses, the canvas he paints on, and proud of his need for every object he sees. He is proud to be incomplete and glad the world exists for him to become more and more complete. The artist's first purpose as he looks at an apple is not to eat it, but to see it—to see its shape, its color, its weight, the way light touches it. Without the apple, Cézanne would not be himself; without the kings and dwarfs, Velasquez would not be himself. Without red, yellow, and blue, horizontal and vertical, Mondrian would not be himself, nor would Renoir, nor any other artist.

When an artist is looking at an object at his seemingly most humble, it is then that he is most proud and most grateful to the forces of the world that made him and things the way they are.

And gratitude, I have learned, is a critical emotion. It arises from perception and intellect. In his essay "Art as Criticism," Eli Siegel writes:

Art is criticism and devotion. Criticism, however, is an accurate interaction of rejection and acceptance. It has been given to man that he be able to like and dislike reality; be for it and against it; indeed, to be a man means that you are always in the midst of antagonism and welcome. The devotion that is art arises from a true relation of antagonism and welcome, not from a

superficial, incomplete welcoming. Only he who has found the universe tough, grudging, or puzzling; or God not so bland, granting, placid, can come to true devotion. Art is the criticism that is also love.

In Raphael's *Transfiguration*, there is critical devotion. The Renaissance painter has used his imagination to put together heaven and earth, death and life, pleasure and pain. And all the time he has organized a composition, critically choosing some details and leaving others out. He has in the sky shown Christ in a triangle within a circle. Light and geometry are together the way criticism and devotion are. In the rough, dark rectangle of the earth, Raphael has shown figures in pain, but with bright drapery. The painter has affirmed life in this painting through his composition of dark and light, of falling and rising, of depth and surface, of what is seen and the unbounded meaning of what is unseen.

Every painting is a means of affirming life and of showing our gratitude for the fact that what is not ourselves is, in innumerable ways, like ourselves.

I believe that beauty can honestly be found in the ugly, dull, ordinary, even painful objects of the world. That is the message of Rembrandt's *Slaughtered Ox*. The permanent opposites of the world are here in the thrusting forward of the dead ox and in

the hidden figure of a woman. Assertion and retreat are motions of reality and they are in us. Assertion and retreat are essential properties of all color, everywhere.

The ox has three directions within it: up, down, and across. The stars, the moon, and the sun, which never die, also have in them vertical, horizontal, and diagonal. The painful, lumbering, awkward quality of the slaughtered ox is redeemed by the pride with which it is lifted and put forward into the light.

My belief that beauty can be found in ugliness would never have existed had I not met Aesthetic Realism. Half of my perception would not exist had I not been taught to see that the terror of the world has some real coherence with its beauty. Like others I have, as a human being, too much in me that is against the meaning of art and the meaning of life. However, on occasion as artist, I have been able to look at the ugliest thing in the world—contempt— and see that it, too, has form. This next painting is an example. In *Still White Life* I looked at myself hiding, and saw that the lively legs protruding from the sheet were, in reality, both against what was hidden and at the same time, through the diagonal motion of the painting, completing the hidden with the shown.

I believe that all art is ethical; that all art, as it puts together what we hate and what we love, our con-

tempt for things with our respect, is being fair to the world and true to its meaning. When an artist wants to see what is hidden as well as what is apparent, he is ethical. He is doing what we all want to do: have what we show be true to, include, be the same as what we are. When an artist finds difference within sameness, when he shows that energy is necessary for repose, that surface without depth is weak, he is ethical. When an artist shows that the opposites in reality can work together at the same time, in the same place, and for the same reason, he is ethical. The greatest sin in the world, according to Aesthetic Realism, is separation. It is in painting, as in all art, that separation and junction are brought into that luminous, critically accurate relation we call beauty.

It is in Aesthetic Realism, founded and taught by Eli Siegel, that what painting is, and the reason why it came to exist in man's mind, is given the meaning it has been waiting for all these centuries.

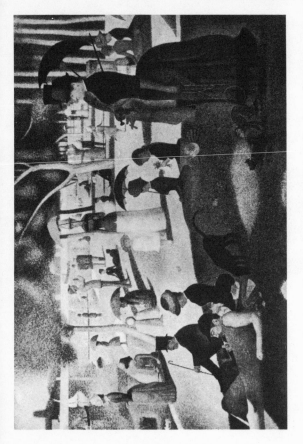

GEORGES SEURAT. *Sunday Afternoon on the Island of La Grande Jatte*
The Art Institute of Chicago

ROY LICHTENSTEIN. Landscape
from *N. Y. 10 Portfolio*, Tanglewood Press, Inc.

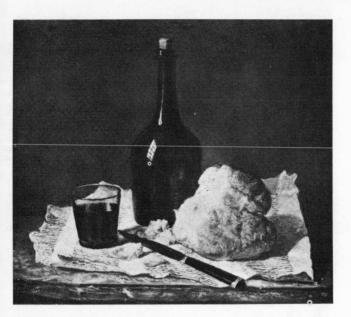

CHARDIN. *Still Life with Bread*
National Gallery, London

Above: PIET MONDRIAN. *Broadway Boogie-Woogie*
Collection, The Museum of Modern Art, New York

Right: RAPHAEL. *The Transfiguration*
Vatican

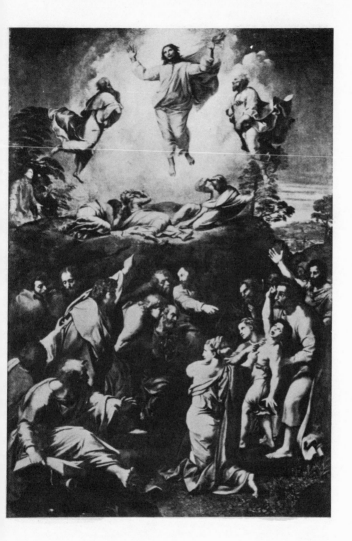

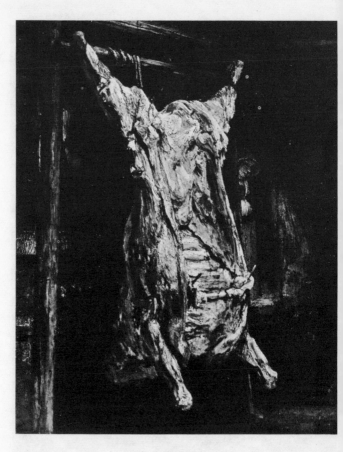

REMBRANDT. *The Slaughtered Ox*
The Louvre

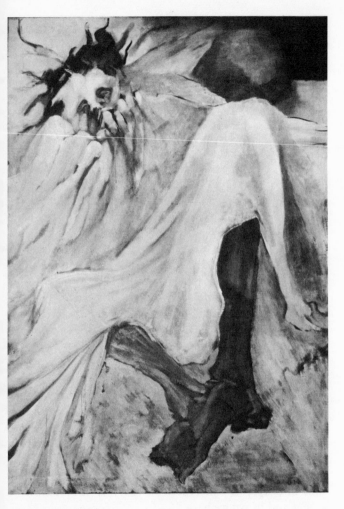

DOROTHY KOPPELMAN. *Still White Life*

Aesthetic Realism
Poetry Class

REBECCA THOMPSON

Rebecca Thompson is an actress and a poet with a degree in history and philosophy from the University of New Hampshire, and a Master's degree in Theatre Arts from Pennsylvania State University. She has appeared on television and off-Broadway in productions of The Glass Menagerie, Our Town, St. Joan, *and* Red Roses for Me, *and is a member of the original cast of* Hamlet: Revisited. *She is also the director of the weekly Aesthetic Realism presentations at the Terrain Gallery.*

EDITOR'S NOTE: That life and art really say something to each other and to us is shown each week in the poetry classes of Aesthetic Realism conducted by Eli Siegel. Recently, he has been using the well-known anthology of Chinese poetry, *The White Pony*, as a springboard for a thematic discussion of the poetry of the world. As this report shows, the way Aesthetic Realism sees the opposites in poetry is coherent with the way it sees them in acting and in painting.

THE TITLE given by Eli Siegel to his lecture of November 8th was "In Poetry, Life and Death Explain Each Other." For some weeks now, we have been studying the poetry of Andrew Marvell in relation to the work of the 4th-century Chinese poet, Tao Yuan Ming. This talk was a continuation of that study.

Mr. Siegel began this lecture by saying, "Since Marvell's poem 'An Horatian Ode upon Cromwell's Return from Ireland' is so much about history and in the midst of life and the midst of a century (1650), it would be well to point out how, just as there is outline and color, separation and junction, slowness and speed, thickness and thinness—how these opposites have with them the most terrifying and common of opposites, life and death. The whole purpose of poetry and art," he said, "is to show that life and death have a relation to those opposites which are less terrifying and unthinkable. It would be well to see how death has been dealt with as a subject, and how something like death is in technique."

During these opening remarks, I never felt so much that the study of reality and the study of poetry were one thing.

Mr. Siegel then read two poems of Tao Yuan Ming —"Shadow Says to Substance" and "Spirit Expounds" —both of them meditative and instances of how death

has been dealt with. The last lines of "Spirit Expounds" are:

> When the end comes, let it come,
> And no more cares beset you.

Said Siegel, "The way life and death have been dealt with shows something about them; but how everything in the technique of art says something about this, will take a long time to show. In the long run, the only consolation is to be found in this: that life and death say something of art, and art says something of them."

Then Siegel read his translation of a poem by Baudelaire, "The Voyage." "What has happened in art," he said, "is that Death himself has become alive."

In "The Voyage," the notion of death as a journey is present. This notion has been around a good deal. The poem begins:

> O Death, old captain, it is time! let us lift anchor.
> This land tires us, O Death. Let us be under way!
> If the sky and the sea are black as ink,
> Our hearts, those you know, have rays of light!

In discussing the poem, which moved me a great deal, Siegel commented, "This first line is one of the great lines in French poetry. There's a certain rhythm

here without gush or a fooling of oneself. Good rhythm does not go along with gush."

Siegel pointed out that in the first line, death is made lovable and strong by being called "old captain." Of the line "This land tires us," he remarked that how much we are bored is a question. "Baudelaire," he said, "happens to be one of the princes of boredom, dukes of ennui, counts of tedium, let alone one of the margraves of lassitude."

Then Baudelaire says one of the most cheerful things: "Our hearts . . . have rays of light!" "What," asked Siegel, "goes on in the depths of us? The 20th century is the century in which the unconscious was complexly insulted. Does depth mean greater beauty and light? Baudelaire says Yes."

Concluding the discussion of this poem, Siegel said, "You can hardly find death more energetic than it is here. The fact that death itself can be a subject of a lively poem says something about it."

The next poem taken up was by Mrs. Letitia Barbauld, the English poet who lived from 1743 to 1825. Her poem "Life," particularly the last stanza, has remained as one of the living things in poetry. It illustrates how the subject of death can be seen. "Are life and death," Siegel asked, "related as color and outline are, rest and motion, solidity and emptiness, beginning and end?"

Here is part of the last stanza, which Mr. Siegel took up line by line:

> Life! we have been long together
> Through pleasant and through cloudy weather;
> 'Tis hard to part when friends are dear;
> Perhaps 'twill cost a sigh, a tear. . . .

"These lines," said Siegel, "have a great chattiness; they are deep and very musical. Written in 18th-century England, they have a similarity to those of Tao Yuan Ming's "Spirit Expounds" of the 4th century in China:

> Ever since birth we have been together
> With intimate sharing of good and ill.

"Mrs. Barbauld's poem *is* a poem," Siegel continued, "because it has in it the massiveness of death and the prattling, infantine quality of life. Her poem has affected people very much." To show this, Siegel read a passage from *English Poetesses* by Eric Robertson which describes how Wordsworth was moved by the poem.

> Crabb Robinson relates that on his quoting the same lines to Wordsworth, the poet made him repeat them again and again, until he had them by heart. "I am not in the habit of grudging other people their good

things," said Wordsworth, "but I wish I had written those lines."

The last poem taken up at this class was an American poem with a long history—"Thanatopsis" written by William Cullen Bryant when he was 23. Said Siegel: "The cause of art says something about life and death. Why can this poem please? Why is it alive?" Here are the last lines:

. . . go not, like the quarry-slave at night,
Scourged to his dungeon, but sustained and soothed
By an unfaltering trust, approach thy grave
Like one who wraps the drapery of his couch
About him and lies down to pleasant dreams.

Mr. Siegel commented: "This poem makes life like death. The sense of death is so much around while all of life is going on."

I was very taken with this, and after the lecture I looked carefully at the poem. I found that what Siegel had said about the poem was true: life *is* made like death, honestly. It is in the very music of the lines. Here is just one instance: In the lines "The golden sun,/The planets, all the infinite host of heaven,/Are shining on the sad abodes of death,"— the *o* sound of "g*o*lden sun" and "h*o*st of heaven" is repeated in "ab*o*des of death," making for a sameness

between the places of life and of death through the music.

Concluding the lecture, Mr. Siegel said: "If eternity is an artist, life and death are two things eternity as art uses. When poetry uses the opposites, is something being said about life and death? I think it is." This statement of Siegel's is one that will be studied for a long time to come.

In the second half of the class, Mr. Siegel took up poems brought in by students. I comment on only two, but this should be said: the critical looking at the students' poems was just as careful and from the same basis as his consideration of the poems by Tao Yuan Ming, Baudelaire, Mrs. Barbauld, and William Cullen Bryant.

The subject of the class was interestingly continued in the discussion of Joan Mellon's poem about autumn. Her poem began:

> The sun shines and it's autumn.
> From the window I see trees
> standing in the autumn sun.

Mr. Siegel commented: "All criticism of poetry has to do with the matter of life and death. The general criticism of this poem is that when the lines fall, they fall too heavily and permanently. . . . The

attempt here is to convey the eerie and suggestive, but it is like Ariel behind a lectern!"

Ken Kimmelman's lines, also about autumn, ended this way:

Sing out as the white of the breaking waves
Makes harmony with clouds of everlasting whiteness,
And rejoice to the composition of Autumn.

This poem brought up the problem in poetry of what Siegel called "splash and arrangement." The poem was seen as having energy, but needing a simplicity of drive. Commenting on the content of the poem, which had puzzled both the class and the writer, Siegel said: "The desire is to get away from fears, notions of yours, and see the large things—in this instance Nature—as a means of liking more the small, fearful things."

And so the class of November 8th came to a close. As it did, I thought how this evening about life and death and poetry was, of itself, poetic.

I Believe This About Photography

DAVID BERNSTEIN

David Bernstein, after graduating from the Brooks Institute of Photography in California, served for four years as a scientific photographer with the United States Air Force. He is now a medical photographer at St. Albans Hospital, New York. He has had a one-man show at the New York World's Fair, and he is a co-founder of the Aesthetic Realism Photographers, who have exhibited in colleges and universities throughout the country, most recently at the Chicago Institute of Design.

I BELIEVE that the philosophy of Aesthetic Realism, founded and taught by Eli Siegel, encourages the photographer to be more involved with reality, to welcome reality more, and to record more exactly what he sees with his camera, instead of using the camera as a barrier against the world. I believe the opposites,

as described by Siegel, are in man and in his environment. How well these opposites are seen indicates how much a person sees and how much he is affected by the world.

Further, I believe that all of the physical and chemical reactions concerned in photography have to do with the opposites, and these same opposites are crucial in ourselves and our lives. To give just one example, take addition and subtraction. In Dye Transfer Color Printing, a photographer has to resort to additive corrections because the matrix has been underexposed and the final print lacks brilliance. In subtractive corrections, on the other hand, a matrix has usually been overexposed and the final print is too contrasty. I believe that addition and subtraction not only pertain to the Dye Transfer Color Printing process, but are basic opposites present in conflict in self. Do I want to add to the meaning people and objects can have for my life, or do I want to subtract from the meaning?

In 1964, Eli Siegel gave a series of lectures on imagination, at which time he pointed out that "imagination shows how the world is in us" and that "to see is to have the world in you." The basic principles in these lectures are the sanest way I know for a photographer to see the world. To show how these principles are related to photography, I take from my

notes five of Siegel's statements—all from one lecture —to give you an idea of how vital they are to the way a photographer sees.

1. "Imagination that hurts a person is different from the imagination that inspires a person."

Now I have known photographers to use imagination to have a secret power over people and objects, to feel superior to their subject matter, and to feel that their way of seeing is the only truth. I have seen photographers waste photographic materials because a feeling of impatience and superiority interfered with the proper respect and attention to technical matters.

For myself, in the years before I began to study Aesthetic Realism, I used to load my cameras and film holders with costly color film and set off for the canyons and arroyos of New Mexico, the deserts of California, the swamplands and mountains of Alaska —and what happened? I was carried away by colorful landscapes, but I didn't really see. If a photographer is cold to what he is looking at, if he separates an object from its deep universal meaning, if he arranges objects before he respects them, he is using his imagination in a hurtful way. Imagination used to respect objects, to join the meaning of the object to your own meaning—that is the kind of imagination that

inspires, and I believe that it is necessary for every photographer to study the difference.

2. *"One quality that imagination has is that the object looked at is deepened and heightened."*

Photographers all over the country, whether they are working in a portrait studio in Omaha or a commercial studio on Fifth Avenue, have a question about imagination and how to use it. If they do not use imagination to become more truly involved with their subject, defects, such as out-of-focus pictures, poor print quality, and weak composition will be evident. Under the focusing cloth, imagination has been used to obliterate one's wife or parents, to magnify financial worries, and to brood over the question "Why am I not famous?"

3. *"Imagination is seeing with personal architecture."*

Like a building, a person has an architecture. There are rooms and corridors; and the arrangement of these rooms and corridors makes either for respect or contempt. I believe that the way Aesthetic Realism sees contempt and respect is crucial in the working life of every photographer.

Aesthetic Realism describes every human being as having two purposes: (1) he wants to use the world

as a means of glorifying himself; and (2) he wants to respect this world *as it is* as a means of liking himself. The fight between these two ways is present all the time and it doesn't stop when you click the shutter. I believe a person can learn from photographs something important about what it means to respect the world.

To show something of what I mean, I have selected four photographs—two portraits and two still lifes. I was affected by all of them and I think they bring up problems that matter to every photographer.

The first is a portrait of an Armenian Jew, Ellis Island, 1924, by Lewis Hine. This man is beautiful. As I look into his eyes, I feel a shining openness that seems to say to me, "I want to be a part of what is not myself. I want to be a part of you, but I also have a right to be different."

I think Hine quite clearly wanted to involve himself with the feelings of this man. His respect for humanity is in his statement: "Two things I wanted to do. I had to show the thing that had to be corrected. I had to show the thing that had to be appreciated." I know from my own experience photographically that it takes courage and imagination to confront another human being directly and honestly and respectfully. Lewis Hine had that kind of courage, honesty, and respect. It is what I am looking for.

The next photograph is of a Shaker Sister by
W. F. Winter. There is a pleasing symmetry here and
there is dignity. The basket she is holding seems jolly,
and I think it contradicts her sad, far-off expression.
A big question for me in this picture is whether this
lady is in herself or is she out?

I have had to ask: How much do I want to be af-
fected by the people I photograph? What is the best
moment to click the shutter? Do I have the patience
and humility to wait for the very best moment? Is this
it? In looking at the photograph of the Shaker Sister,
I am not sure this was the best moment. I am left
wanting to know this lady better than the picture
allows me to.

This next picture is a shocker. It is by Frederick
Shepherd, and when I first saw it, it shook me up. I
still haven't made up my mind about it. There is a lot
of humor here, but there is a lot else besides. The
photographer has taken two very different objects
and related them in a violent way. I think this is a very
critical photograph—critical of the way we can want
to grab the world and devour it.

Coming out of a photo-school factory where all of
the students acquired pretty similar portfolios—still
lifes of artists' modelling stands with broken whiskey
bottles, for instance—I know that there can be very
proficient technique and no real imagination. As I

said, I haven't come to a definite opinion about this picture, but one problem it brings up I certainly respect very much. It is my belief that when people are able to laugh at the ugly, it is on the side of God. I have been seeing this in attending a series of lectures Eli Siegel is presently giving on religion; and this photograph makes me think of Siegel's statement introducing his definition of humor: "Religion is the art of making the intolerable tolerable. Humor is the art of making the intolerable funny. See how close they are?"

I had been working with arranged set-ups and I wanted to do something in the simplest and most direct way I could. I chose this particular chrysanthemum because of the uniformity of the top petals and the wild disorder of the bottom petals, and then I shot it head on, trying to get into its meaning as fully as I could. I brought this photograph to a lesson the Aesthetic Realism Photographers had with Eli Siegel.

Siegel pointed out that there was a feeling of exaltation here. He said, "The effect is of something gorgeous—with that multitudinous white, that opulent white rising above it all. And in the meantime there is a tendency to droop. Tragedy says that a man can be high and yet unfortunate—Hamlet, Oedipus, Othello, Macbeth. This is present in photography,

too. I think the flower is not sure of its purpose in this world. Wouldn't you say it was caught in a storm of uncertainty?"

I was surprised by these comments, but I felt they were true to my purpose in the photograph and true to my mind as a person with questions and convictions.

4. "The subjective is the objective."

Eli Siegel is the first person to state this concept exactly in this manner. Mr. Siegel said to me at the first Aesthetic Realism Ethical Study Conference I ever attended that in order for me to have less pain from the way I saw my uncle, I would have to let go of a personal ownership, and place my uncle in the impersonal world—the world of Hamlet and photography.

5. "Every passion has knowledge."

At a recent photography workshop course given by Lou Bernstein, Mr. Bernstein introduced the class to the Siegel Theory of Opposites. One of the students, who has taken much philosophy in college, was skeptical about how the opposites would actually work on location. He also asked Mr. Bernstein's opinion of a well-known nature photographer. Mr. Bernstein was critical of the nature photographer because of a

generally aloof attitude in his work, and he recommended to the student that he go into the woods with the conscious purpose of seeing whether opposites such as freedom and order, warmth and coolness, repose and energy, logic and emotion, inclusion and exclusion were there together working at the same time.

That weekend the student went with his wife into the woods and came across a twig that remained still in a rushing stream. He photographed the scene and said that he was actually trembling with an aesthetic emotion. He felt a real passion based on the knowledge of the Siegel Theory of Opposites; and contrary to his past philosophic studies, this passion was having a physical effect on his mind and body.

Aesthetic Realism principles cannot be stuffed into a gadget bag along with film and filters. They have to flow through one's veins as an integral part of oneself. I believe these principles should be known throughout the world. I see this as my job.

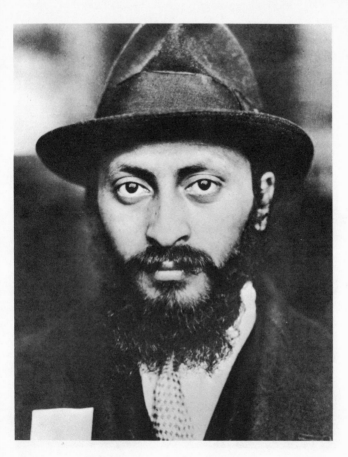

LEWIS HINE. *Armenian Jew, Ellis Island, 1924*
Lewis Hine

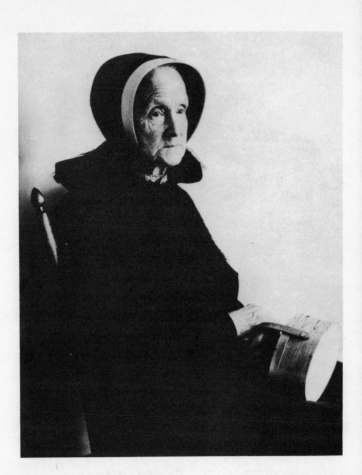

W. F. WINTER. *Shaker Sister*

FREDERICK SHEPHERD. *Still Life*

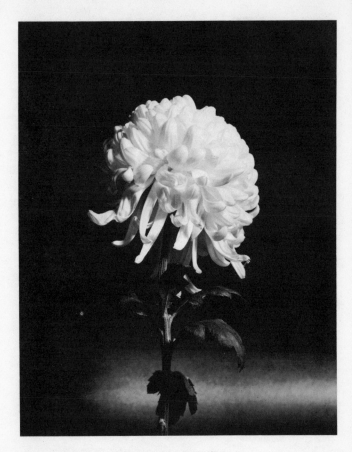

DAVID BERNSTEIN. *Chrysanthemum*

I Believe This About Art

CHAIM KOPPELMAN

Chaim Koppelman is one of the best-known printmakers in America. Recently a half-hour television program was devoted to a discussion of his work. A winner of two Tiffany grants, Mr. Koppelman is in Who's Who in American Art *and his graphics are owned by museums both here and abroad, including the Museum of Modern Art, the Metropolitan Museum, the Library of Congress, and the Victoria and Albert Museum in London. He is the head of the Printmaking Section of the School of Visual Arts.*

I BELIEVE that the opposites as described by Eli Siegel are the crucial thing in every aspect of art, including the print, my own medium. Opposites such as freedom and order, depth and surface, logic and emotion are crucial in:

53

1. the printmaker's intention
2. in his technique while working
3. in the finished print itself
4. in the viewer's response, including that of the critic.

Opposites lie at the very heart of all the printmaking techniques. Silk screen, based on the stencil, couldn't be without the open and closed. Lithography depends on the fact that water and grease repel each other. In the woodcut, what is below the surface and cut away does not print; what is above the surface, prints. In etching, the exact opposite holds true. All pits, scratches, and grooves below the surface take the ink and print; the surface is wiped clean and doesn't print.

Every finished print is a study in opposites. This woodcut, *Collision*, by Robert Conover is. Technically the massive forms are lightened, made airier and more delicate, by their transparency and lighter tones. Conversely, the smaller "slivers," darker and more opaque, take on greater density and weight. Both massive forms and slivers have diagonal directions. These are some ways Conover makes large and small more alike, more one.

The opposites were central in the response of German art historian Heinrich Wölfflin to the etchings of

Rembrandt, whom he cared for a great deal. Wölfflin, writing in his *Principles of Art History*, first published in 1915, in a chapter appropriately titled "Clearness and Unclearness," discusses one of Rembrandt's finest etchings, *Christ Preaching:*

> The figures that surround the preaching Christ in Rembrandt's etching are only partly distinguishable. There is a residue of unclearness. The more distinct form arises from the ground of the less distinct, and therein lies a new interest.

I believe that every artist wants to put opposites together in his work, and these are the same opposites he wants to put together in his life. I believe that Eli Siegel's statement, "The resolution of conflict in self is like the making one of opposites in art" is true for every artist as it is true for every person.

However, artists usually do a better job on the canvas than in their own lives. This is likely true of Willem de Kooning, whose paintings of women are now at the Knoedler Gallery. Men see women in two ways: as desirable goddesses and, at another time, as bitches. These two pictures are separate, and when we are seeing one way, the contrary way can be forgotten.

Here in *Woman, I,* de Kooning courageously makes the two pictures one. This lady is desirable and fero-

cious at once. In her coexist pink color and sharp angles, teeth and the curvaceous. The woman we curse and the woman we worship have merged, making for a powerful aesthetic effect.

This idea is, I believe, corroborated by Louis Finkelstein in his article "The Light of de Kooning," *Art News*, November 1967. He writes:

> There is also in de Kooning's color a distinctly, what I can only call moral quality, a suggestion of seductiveness of the flesh together with the corruption of the flesh. One finds the same expression in Bosch and in Ensor—sweetness, delicacy, and delight, tinged with bitterness and cruelty.

In my own work, I want to have both fixity and flow. I find as a person I also want to stay put and be on the move. Here is an excerpt from an Aesthetic Realism lesson I had with Eli Siegel on the subject. My life and work benefited from what I learned. I had this lesson on June 2, 1949.

> KOPPELMAN. Last night we were lindy-hopping and jitterbugging and it seemed to be all flow. Then I remembered my drawings, and people having said that they seem to be drawings of sculpture; that is, a holding on to things in one spot. I remember my poems, too, years ago, and even now there is that being iso-

lated, rigid, with nothing moving in it from one place to the next.

SIEGEL. There is a tendency on your part to separate the deep perception of reality. One of the things you have to go after is to feel that when you are feeling good, you are just as deep as when you are feeling bad. This I don't think you have yet. Take the fight between Delacroix and Ingres. Ingres went after outline and shape, something comparatively restrained, and Delacroix went after much motion and color . . . you know, the big warfare. Now, is that warfare in you?

Yes, that warfare was in me. In this aquatint done in 1963, *Voice in Granite*, I wanted to bring something rising and luminous to a fallen figure. Central in my idea was the desire to bring hope to despair. The person coming out of the rocks is bringing something kind and hopeful to the fallen warrior. I have come to feel more that hope or lightness is as deep as darkness or feeling bad.

I believe that there are two kinds of art, good and bad. What makes a work good or bad is not a matter of personal opinion, but is universal, constant. What makes a work good, successful, beautiful does not change with time, geography, social structure, prevailing tastes or one's individual preferences. After

having tested his aesthetic concepts in literally thou-
sands of works of different periods, in different styles,
in different media, for more than twenty years, I say
that Eli Siegel's Theory of Opposites is the key to
what is good or beautiful in art. I have seen that the
greater the work of art, the richer, more surprising
and subtle the play and fusion of the opposing qualities
in it. In a bad work of art, the opposites are present,
but either they fight too much, or they are limply
there.

Let us take two examples: one a good work, the
other bad, in relation to Siegel's question on Truth
and Imagination from *Is Beauty the Making One of
Opposites?* Siegel asks:

> Is every painting a mingling of mind justly receptive
> of what is before it, and of mind freely and honorably
> showing what it is through what mind meets?—is every
> painting, therefore, a oneness of what is seen as item,
> and what is seen as possibility, of fact and appearance,
> the ordinary and the strange?—and are objective and
> subjective made one in a painting?

Truth and imagination serve each other well in this
trenchant painting of his own family by the German
expressionist Max Beckmann. The painting is titled
Family Picture and is in the collection of the Museum
of Modern Art. The work is both very funny and sad.

Jammed into a small room, the relatives in this closely-knit group are alienated from one another. Beckmann has intensified the situation of closeness and remoteness in family life. It is precisely this intensified oneness of oppositions, technically and in the subject matter, that gives this picture its power and authenticity.

Truth and imagination fare less well in Andrew Wyeth's *Christina's World*. What seems so realistic a presentation of the world lies about its true structure. Things are a oneness of separation and junction in the world. Here, as Dorothy Koppelman pointed out in her *Washington Independent* article on Andrew Wyeth, they are not. There is insufficient variation in the ground, and too much separation among Christina, the buildings, and the ground. Wyeth plays off the isolation of things against their kinship. Imagination is used not to reveal the true order of things, but to conceal their actual state. This work is less true to the facts than Beckmann's *Family Picture*. Both Beckmann and de Kooning distort appearances in order to more fully present the truth. The seeming verisimilitude of a Wyeth distorts the truth.

I believe that art is not an escape from life. There is no such thing as a good work of art that presents a false picture of reality.

To understand art I believe it is necessary to be interested in people, including ourselves. To understand ourselves and others, genuine respect for art is a must. Once I believed otherwise and wanted to keep people and art separate. Like others, I used art to get away from people, mainly the family. I remember how shaken up I was hearing Siegel tell a fellow artist, "Your mother and the Renaissance are in the same world. Use one to see the other better." Now, years later, I can show that the two are related. I have learned how. My mother, Sadie Koppelman, like all of us, was proud and humble. She didn't do too well composing these in herself. Piero della Francesca, the Renaissance painter, composed humility and pride in his fresco at Arezzo, where the Queen kneels gracefully with head bowed. Yet she is dignified. Seeing this, both my mother and Piero mean more to me.

I believe that technique begins with the way an artist sees, not when he first applies his brush to the canvas. Criticism of technique, to be completely effective, must begin with the way an artist sees the world, his family, sex, money, objects, other people. The way an artist sees freedom or fame, for instance, can either impede his artistic powers or increase them.

Ten years ago I said that contempt is the greatest enemy of art, and the greatest enemy of contempt

is the Aesthetic Realism of Eli Siegel. I still say it. Contempt, according to Aesthetic Realism, is the difference between what a thing deserves and what we give it. The sculptor Brancusi said, "The beautiful is absolute justice." It is. Beauty can only arise from a mind that is just, wants to see things exactly and give them all the meaning they deserve. You can't switch from contempt outside to respect in the studio and get away with it. For example, everybody, including artists, hides too much. Art demands that the artist show what he feels precisely, with no substitutes. Hiding is a form of contempt. It says that nobody is good enough or deserves to see what we really feel. When hiding and showing are in conflict in an artist it affects his work badly. Siegel has pointed out how symbols can be used in art to hide, rather than to show what the artist feels. Ambiguity, a darling among the avant-garde today, can also be used cleverly to conceal.

Aesthetic Realism is, I believe, the new art education. Eli Siegel has given the world a tremendous thing —a method to relate art, the world, and ourselves in a way that adds to the meaning and beauty of all three.

Above: ROBERT CONOVER. *Collision*

Right: REMBRANDT. *Christ Preaching* (detail)

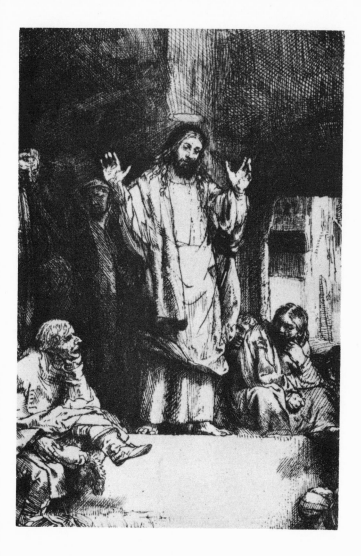

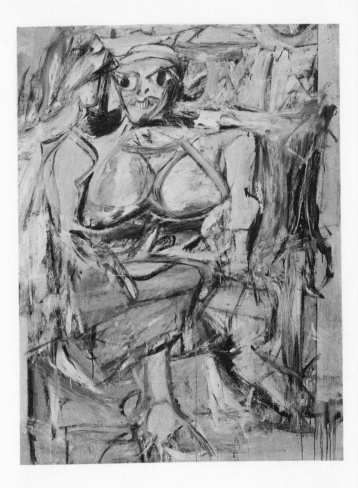

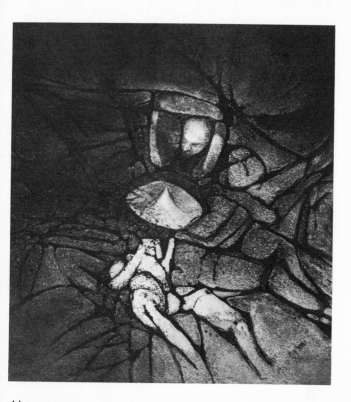

Above: CHAIM KOPPELMAN. *Voice in Granite*

Left: WILLEM DE KOONING. *Woman, 1*
Collection, The Museum of Modern Art, New York

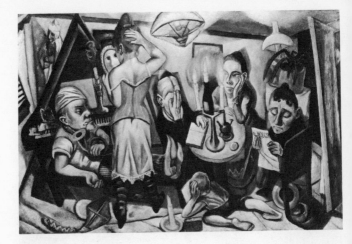

MAX BECKMAN. *Family Picture*
Collection, The Museum of Modern Art, New York
Gift of Abby Aldrich Rockefeller

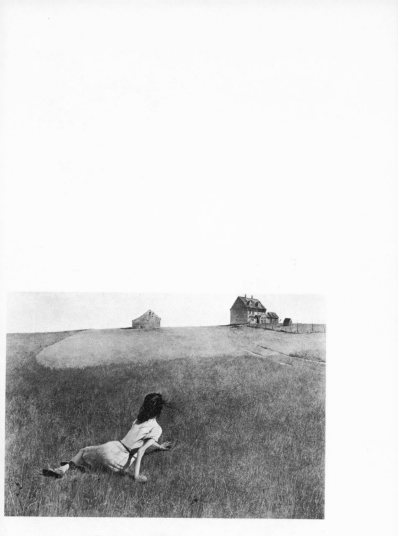

ANDREW WYETH. *Christina's World*
Collection, The Museum of Modern Art, New York

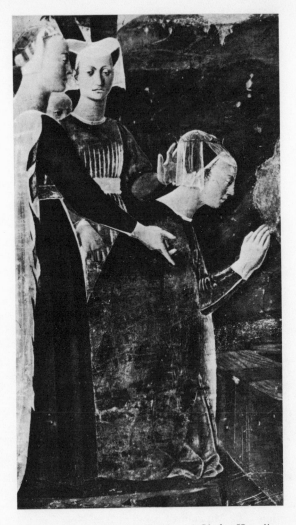

PIERO DELLA FRANCESCA. *The Queen of Sheba Kneeling with Her Retinue.* Arezzo, San Francesco

National Ethics Report

ALICE MUSICANT BERNSTEIN

*Alice Musicant Bernstein is a graduate of
Brooklyn College. Her essay, "Chaucer as
a Critic of Love and Marriage," appeared
in the journal,* Studies in Literature. *She
edited the* Terrain Gallery *publication,*
Damned Welcome, *a book of Aesthetic
Realism maxims by Eli Siegel.*

EDITOR'S NOTE: Aesthetic Realism sees art and ethics
as inseparable. It is therefore concerned with the ethics
shown in events as reported in the press. For example,
there are the National Ethics Reports that Eli Siegel pre-
sents periodically to his classes, in which he uses articles
from current newspapers and magazines. The National
Ethics Report which Mrs. Bernstein gives an account of
took place on November 10th, just three days after the
1967 elections.

ELI SIEGEL approached this class with a wealth of ex-
perience as a teacher of ethics, a scholar of history,
and a critic. His work in these fields began in the late
1920's with his daily column in the *Baltimore Amer-*

ican and is documented further in *Psychiatry, Economics, Aesthetics* of 1946.

The texts for the present talk were 13 articles from the *New York Times*, the *New York Post*, and the *Daily News* of November 9, 1967, two days after Election Day.

Mr. Siegel began by saying: "Religion can be seen as one of the social sciences in so far as it affects people every day. Economics, politics, government must be honored if religion is to be seen truly. Ethics asks: Is there a force telling us what to do? No person is exempt from this question. Every person has been troubled by ethics."

The first article he used was from the *New York Times*. Lawrence Davies reported from San Francisco on the referendum voted on there for an immediate cease-fire and withdrawal of American troops from Vietnam:

> The complete tally of votes . . . gave, Yes, 76,632. No, 132,406. The heaviest "yes" vote . . . came from districts in which the Negro population is heavy . . . and which were the scenes of violence in the summer of 1966. Precincts in the heart of Haight-Ashbury, "Hippieville," also returned "yes" majorities.

Siegel commented: "This voting was a tremendous ethical occurrence. The *New York Times* is unethi-

cal; so is the *New York Post*; so is the *Daily News*, and so is every paper in this country. To have the means for information private, and to use information as a means of sale is already to be unethical. I say this soberly. The people on the *Times* are more and more troubled by their bad ethics."

Siegel went on to say that the reason this story on the referendum is unethical is that the election points to the fact that one person out of every three is against the war. Instead of saying this simply, the *Times* chooses to see those opposed to the war as sex deviates, out-of-line professors, and other "minority" groups. It was pointed out that when one sees in history how few members of the Abolition Party there were thirty years before the Civil War, or how few persons were opposed to the Nazis in the early 1930's, the number of dissenters in San Francisco was tremendous.

Siegel continued: "The idea that there should be one out of three! The very center of the population is expressed. If one out of every three loved the ballet, what a country we'd have. The *New York Times* has always accented the left as queer. And it demonstrates that when you want to defeat something, your ethics is shown by what you will do to have the defeat take place." Siegel pointed out that if San Francisco is representative of cities in America, it means that there are 60 million people in this country who believe the

present administration does not represent America in this war. "The *New York Times*," he said, "feels that politics belongs to them. They would never print this headline: 60 MILLION ARE AGAINST THE WAR!

Next, Siegel took up a *Times* editorial called "Drift to the Right," which brought up questions crucial to ethics. Siegel put them this way:

1. What place will the Negro have in American life?
2. What will America do in Vietnam? Will it admit that it was misled by unethical people?
3. What does a person by being alive deserve from the world as wealth, the world as a cause of all his desires?

The *Times* editorial dealt with the election. Siegel said, "While the Negro is not the only subject of ethics, the fact that in two places—Cleveland and Gary—Negroes were elected, is a tremendous thing. Ethics doesn't have a chance unless it is associated with power. The Negroes took the complacent white folk and shook them up. The *Times* would never think of this."

Commenting on the elections in Mississippi and the defeat of Mrs. Louise Hicks in Boston, Siegel showed that ethics are as close as one's pulse, not in a far-off academic world. He said, "Most people don't think

too much of themselves, so if there are 15 million peo-
ple whom they see as inferior to them, they like that.
If Negroes are really people, then the whole basis of
superiority is gone. These elections would never have
had the results they did unless the white folk were
impelled to take the Negro complaints more seriously.
The Negroes are getting bolder. This will go on. To
go after stopping this doesn't make one look good to
oneself."

It was said that the *Times* summation of what oc-
curred in Mississippi lacked something. How the Re-
publicans came to be so strong in the South remains
to be explained. "The word *Democrat*," Siegel said,
"has taken on a sad, funereal quality. The *New York
Times* doesn't want to say so. Capitalism has its lunatic
fringe, and there are people who couldn't be conser-
vative enough. Anybody who has a bad temper and
a few possessions is a likely member of the Conserva-
tive Party."

Continuing, he said: "Mississippi is the only state
in which there are more Negroes than white people.
People there have been divided from the beginning.
There is the sheriff and marshal type, and also those
with a feeling for religion and thought. Faulkner and
his family stood for the latter. Faulkner in his novels
showed the Southern mind at its most repulsive but
still complex."

In a consideration of Tom Wicker's *New York Times* column on the New York elections, Siegel said, "The defeat of the New York State Constitution is a valuable thing. The relation of private and public in terms of religion has made for a great deal of pain. The Catholics do miss something in their own schools, and they also want to educate themselves any way they like. A good many Catholics feel this campaign, to get public funds for parochial schools was a mistake. . . . The best thing is that Catholicism is more in the sun. There's not the feeling that religion is secret."

The next article discussed was from the *New York Post.* James Wechsler's column, "Washington: Very Depressed Area," tells of:

> the detailed findings of 20 reporters . . . who have spent recent days lending sympathetic ears to scores of public servants. The summary . . . of the dominant mood in LBJ's terrain is this: Disenchantment . . . Suspicion . . . Hate . . . A sense of being misunderstood by the populace, persecuted by Congress, debauched by the White House, and betrayed by colleagues.

Siegel commented: "There is a great deal of conscience trouble. As soon as you're in politics, you give up your feelings. You give up what you are as a per-

son. Somewhere—though it's hard to see—J. Edgar Hoover must have an inner life. That inner life, I think, is chiefly fear and self-contempt of an accurate kind."

Next came a column of Drew Pearson's which dealt with Ronald Reagan's "dismissal of two sex deviates from the Sacramento staff" and his "investigation of homosexuals in the official family." In discussing this column, Siegel said, "Ethics takes in bribery, rigging of voters, and, in recent years, variations in sex. Reagan did what used to be done in politics: you deny it with the greatest sense of injury. Reagan should have said, 'Certainly I have people like that. I want all of America to be represented!' "

Considering William Buckley's column in the *Post*, called "Commies and Junkies," Siegel pointed out that the idea here was to show that a hippie is the result of the small print in Karl Marx. "A hippie," said Siegel, "is a strange and diverse hedonistic leftist. It's a mingling that hasn't been before." And about this sentence of Buckley's: "Drug-taking seems to be a consequence of Communism," Siegel said, "Marx is suddenly a druggist! . . . Buckley has the quality of the Philadelphia lawyer with a touch of nightmare."

A surprising and moving article was Betsy Bliss's in the *Post*, "The Teens Who Starve to Death." It reported on a rare psychological disorder "charac-

terized by a refusal to eat . . . and an obsession with weight." About this, Mr. Siegel asked: "Do we have a right to harm ourselves, whether slowly or progressively or instantly? Persons are always looking at themselves, and how wisely they do, has to do with ethics."

Finally, Siegel used three letters in the *Daily News* as evidence for his earlier statement that persons who voted for the San Francisco referendum are representative Americans. "The Vietnam matter is part of America now," he concluded. "And any attempt to make it less is lying."

The passion that Eli Siegel shows for the fate of ethics in America and the fate of ethics in a person is courageous and based on a scrupulous care for facts. It can encourage us, as we read tomorrow's newspaper, to ask of the most frightening and confusing matters: What is the ethical question here? Aware of this, we have a better chance of making sense of what we read.

I Believe This
About Photography

LOU BERNSTEIN

Lou Bernstein is one of the most respected photographers in the country. He has exhibited widely all over the world, including the Family of Man *show and Expo '67. His photographs are also to be found in the* Encyclopedia of Photography. *He teaches two workshops in which he uses the Siegel Theory of Opposites as his critical method. In 1967 he had a 25-year retrospective show of his work at the Terrain Gallery. Recently, Mr. Bernstein has joined the staff of the magazine* Camera 35, *to which he contributes a monthly column.*

I AM happy for this chance to tell you some of the things I believe about photography. First, I believe that every photograph is a statement by the person taking the picture about how he feels and sees the world and himself. My own photographs are a kind

77

of history of my deepest feelings and how they have changed over the years, and I think this is true about the work of every photographer.

Another thing I believe is that good photographs begin with an honest desire to know yourself. One of the most important things a photographer needs to know as well as he can is how contempt and respect work in him. For myself, I have learned that contempt interferes with taking good pictures. I have found that greater respect makes for deeper emotions and more sureness about what my purpose is in taking pictures. In teaching photography, I hope to teach my students the same thing I am trying to learn myself— how to respect things outside myself. I think this is a good thing for any person, and necessary for anyone who wants to be a good photographer. As I say this, I am not minimizing the necessity for a thorough knowledge of the elements of design, organization, and technique, but even these things begin with contempt and respect in ways that I'm sure would surprise you. For instance, I discovered that it was only when I consciously began to increase my respect in the darkroom that I was able to stop making grayish, washedout prints.

I believe every photographer needs the best criticism he can get, not only of his work but of himself. I know I will always be grateful to my friend, the pho-

tographer, Nat Herz, because he told me I would find the criticism I was looking for in Aesthetic Realism. Though it took him three years to convince me, he didn't give up. I had been studying Aesthetic Realism only a few weeks when I had an Art Inquiry in which Eli Siegel discussed 16 of my pictures. In talking about these photographs, he asked me questions I had never thought about before in my life.

After pointing out that the attainable seems to be a big subject in my work, Siegel asked me, "What do you think of the unattainable?" In discussing one of a series of pictures I did of children playing in the spray from a fire hydrant—the picture of a boy holding another boy on his shoulders—the question was: "Do you like to be burdened or unburdened?" And still another question was, "Do you think when two things, however different, are put in the same light, somehow they come to be a little the same?" —Well, that Art Inquiry started me thinking in new ways, and I felt the presence of honesty, knowledge, and kindness that I hadn't known existed. I didn't fully understand what was happening then, but later I saw that this honesty and kindness came from principles which I have been able to understand better and better and to put to use both in my life and in my work.

One of these principles is that beauty is always the making one of opposites, and this making one of op-

posites is what we want to have happen in ourselves. I believe that opposites are crucial in the success or failure of every photograph and that every technical problem in photography has to do with them, too. When Eli Siegel put down his 15 questions, *Is Beauty the Making One of Opposites?*, he did something important for all artists, including photographers, but unless they want to be critical and test it, they'll never find it out. One thing I have learned is that if you don't put Aesthetic Realism to the test, you'll never know if it works. Part of my own testing has been looking at photographs, both my own and other people's, and asking myself: How important are the opposites in this picture and in my response to it?

Here are a few of the things I have seen.

This photograph of a blind musician is by Andre Kertesz. It is a very strong picture, and the reason, I believe, has to do with Siegel's question about Surface and Depth:

Is painting, like art itself, a presentation of the "on top," obvious, immediate?—and is it also a presentation of what is implied, deep, "below"?—and is art, consequently, an interplay of surface and sensation as "this" and depth and thought as "all that"?

This might strike you as a pathetic picture but I don't think it is. Even though this man is blind and

needs a little boy to guide him, he is using a musical instrument to express himself. He is communicating. Blindness is not only blindness anymore. Looking at this picture, I learn about myself. Although I do have sight, there are things I have great difficulty communicating verbally, and this picture is saying to me there are many ways of getting your message across to other people, even though there may be impediments. This is some of what is implied, deep, below the surface in this photograph.

About the organization of the picture, I think there is some interesting conflict between the background and the foreground, with the position of those two white windows. You'd think the clash would hurt the picture but it doesn't—the photograph is much too powerful for that. This photograph belongs to an early period in Kertesz's work. I think he is clearer in his organization today than he has ever been. His clearest statements are in his most recent work. This encourages me, too.

Cartier-Bresson is a photographer whom I deeply respect, and his work has had a large effect on me. This famous picture of children playing among the ruins in Spain, I think answers Yes to Siegel's question about Logic and Emotion:

Is there a logic to be found in every painting and in every work of art, a design pleasurably acceptable to

the intelligence, details gathered unerringly, in a coherent, rounded arrangement?—and is there that which moves a person, stirs him in no confined way, pervades him with the serenity and discontent of reality, brings emotion to him and causes it to be in him?

In this picture, the children look free and the devastation seems less important than the good time they are having. In terms of its composition, the ruins are a semi-circle which all of the children are within. I think Cartier-Bresson is showing us that destruction and joy are more closely related than we usually realize. These children could so easily have been sad and angry amidst all of this devastation, but that is not what we see. I certainly wish I could take some things in my life the way these children are taking what happened in theirs. We all know there is something like devastation in our lives, but this photograph is telling me: You don't have to see these things only as tragic. There is hope and you can still find joy in life —that is what the children are saying to me. Notice that the semi-circular line of the ruin is a gay line. It has a lot of motion. From the foreground to the background, I find a lot of happy meaning here.

The two children on the right and on the left are a little aloof and suspicious. They seem to be the most questioning people in the picture. Surprisingly, the boy on the crutches seems to be having less difficulty.

And don't you feel a lot of hope in the whites of this picture? We are looking at tragedy here, but the tragedy has lightness. The picture is saying that even with tragedy, we, like these children, have a choice about how to see it.

Now we have two photographs, very different, both of which have to do with Eli Siegel's question about Truth and Imagination. This photograph of an old woman is by a German photographer, Thomas Höpker. To begin with, it is certainly not an Alice-in-Wonderland picture. The old woman, with not much left in her life, is holding a doll. Now, the facts are that the woman is alive; the doll is inanimate. But as you look at the picture, don't you feel that the doll appears to have more life than the woman? There is more grace and life in the doll's hand than in the woman's. This is a very dramatic picture and I am deeply affected by the meaning I see in it. The photograph says to me that we all want to find some meaning and comfort in something outside ourselves, just as the blind man could find comfort and strength in his violin. Every person is looking for something outside himself to hold onto and sometimes he finds it. I see this as a very kind picture.

The three photographs we have seen so far all deal with painful subjects; but in each one, something painful is shown by the photographer to have an element

of lightness that makes these painful scenes a cause of pleasure. There is an Aesthetic Realism maxim I like which says: "No one has yet found out all the ways that joy may be had, or all the ways that pain can be seen usefully." The photographers who made these three photographs saw pain usefully. They showed compassion for mankind, and whenever I see that, I respect it deeply.

Now we have a little flower in which I saw a court jester. One of the differences between this picture of mine and the others is that a flower doesn't have emotions it can talk about. Still, it does have a feeling of life in itself, and it has to wait for someone to recognize something in it. I felt that this lonely little flower up against a blank wall was looking for some recognition, and as I realized that something in nature could have this human meaning, I was moved. I was astonished at what my imagination reached out and helped me to see in this flower. I believe most people, including photographers, take too many things for granted. We could all find much more excitement in things if we looked more deeply, both within ourselves and at what is around us.

Often when I have told people how important Aesthetic Realism is in my way of seeing, they have said to me: "But you were a good photographer before you knew Aesthetic Realism." The point is that

through Eli Siegel's criticism, new doors have been opened up for me. I have become more aware of my own possibilities, including the possibility of finding great drama in subtle situations which once I would simply have taken for granted and passed by. I am able to include more of the world in my work and to find order in what once seemed only disorderly. I am not so quick to sum up situations photographically or otherwise; and when I do, I know how to be critical of myself.

I have learned to respect patience and good will, and this matters both in my work and in my life. If changes like these can happen to me, I believe they can happen to anybody; and if they do, I believe we'll have happier people, better photographers, and more good photographs.

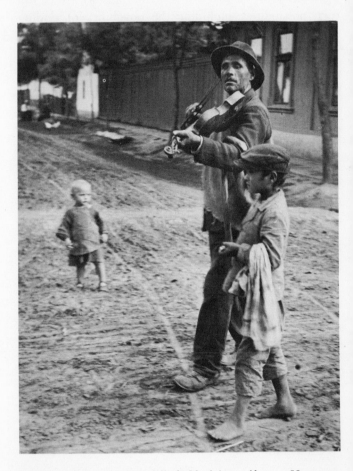

Above: ANDRE KERTESZ. *Blind Musician, Abony, Hungary, 1921.* Andre Kertesz

Right: HENRI CARTIER-BRESSON. *Children Playing in the Ruins of Spain, 1933.* Magnum

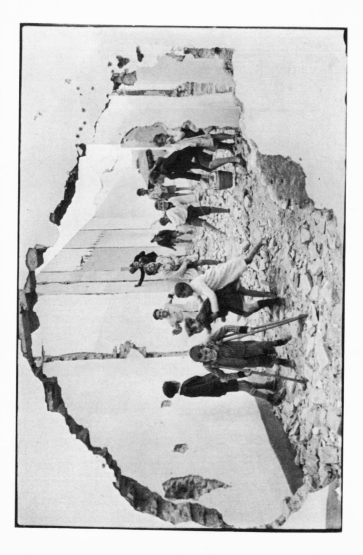

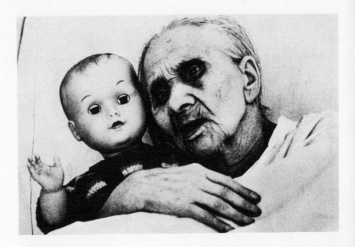

Above: THOMAS HÖPKER. *Old Woman with Doll*
Thomas Höpker, Germany

Right: LOU BERNSTEIN. *The Court Jester*

I Believe This About Acting

ANNE FIELDING

Anne Fielding has studied acting with Michael Howard and musical comedy with Charles Nelson Reilly. An Obie Award winner, she has been seen on and off-Broadway and on television both here and in Canada. Miss Fielding appeared as Juliet in Romeo and Juliet *and as Hermia in* A Midsummer Night's Dream *for the New York Shakespeare Festival, and was a member of the American Shakespeare Festival for two years. She is part of the original cast of* Hamlet: Revisited. *On the faculty of the HB Studio as a teacher of musical comedy, she has been seen most recently as The Girl in* The Fantasticks.

IN *An Actor Prepares*, Constantin Stanislavski writes:

A real artist must lead a full, interesting, varied, and exciting life. . . . He should study the life . . . of the people who surround him. We need a broad point of view to act.

My first acting training at the School of Performing Arts was based on the Stanislavski method—a method I have enormous respect for. He says: "We need a broad point of view to act." That is exactly what Aesthetic Realism provides. It is broad and exact at once. Eli Siegel knows the nature of self more truly than anyone in history, and he describes what selves and actors are looking for. "People are trying to put opposites together," says Siegel. Actors are also trying to put opposites together.

Aesthetic Realism says further that the purpose of acting is to care for the world honestly, not to escape from it. This is true about acting of every period and style, and it is new in theatrical education.

I have learned that acting shows a person's desire to become other people as a means of becoming more oneself. Anything else is untrue to acting and untrue to the self.

I believe that the opposites as described by Eli Siegel are present and crucial from the moment we have a script in our hands, a character in our minds, through all the rehearsals, up until the final performance. Even the remembrance of a performance has the opposites in it.

There are Spontaneity and Plan at every moment. An actor has to be willing to be surprised, even as he

has a scene or an entire play carefully thought out. We have to know our lines and movements and cues and inner desires, let alone what we are doing and where we are; and at the same time we must welcome and even look for the unexpected.

Great actors have spontaneity and plan working simultaneously. For example, in a scene from the film *On the Waterfront*, Marlon Brando did something wonderfully unexpected with a glove. He is walking along with Eva Marie Saint, interested in her, shy, but trying to appear self-assured. Accidentally, the actress dropped her glove. Brando picked it up, went on talking, and, as if he was unaware of what he was doing, put her small glove on his ever so much larger hand. Another actor might have ignored the glove, or perhaps picked it up and given it back to her, or even stopped the scene and insisted on doing it over. But Brando welcomed the unexpected, and that scene is famous—talked of in acting classes everywhere as an example of spontaneous creative imagination. You cannot tell whether it is planned or unplanned. It is both. And it is art.

Drama critics more and more point to opposites as crucial, though they don't *say* they are opposites. Clive Barnes, describing the revival of *The Little Foxes* at Lincoln Center, wrote that one of its outstanding qualities was "a natural breathing interplay

. . . a spontaneity . . . even a *measured spontaneity*." (Italics mine.)

In every part an actor plays there are Sameness and Difference. The actor and character must become one. In the book *Actors on Acting*, the editors write: "This identification with the role becomes a complex problem for the actor." And Stanislavski talked about "living a part." He says: "He (the actor) must fit his own human qualities to the life of this other person, and pour into it all of his own soul."

I have learned from Aesthetic Realism that as the actor gives life to a character, he, in turn, is *given* life by that character. The more a role truly affects us, the more we come into our own. We are added to by every part we play. Juliet is now part of my life, and I am more me because I played that part.

In the essay "Art As Life," Eli Siegel writes: "Our lives are a making one of difference and sameness. Within the I is a tremendous presence of something utterly different, something akin to everything." Acting shows that this is true. Tommaso Salvini, the great 19th-century Italian actor, observed that he had to be in sympathy with every character he played. "One may sympathize even with a villain, and yet remain an honest man."

And there are sameness and difference *within* every

character. Moods and aspects, subtleties and variations are in each role we play. No person is just one way. But both actor and audience must believe that the character in Act I is the same in Act III, however different that character becomes.

When I played Sasha in Chekhov's *Ivanov*, I had to make a vast emotional change within a short space of time. In Act I, she is a young girl making fun of stodgy people at her birthday party, romantically in love, careless about the meaning of life. In Act IV, several years have gone by and she is older, bitter, and angry. I found myself some nights simply feeling I was not the same person in Act IV that I had been at the beginning of the play. How could I make such a swift change in such a short time? I seemed like two different people. But there were performances when I felt I *was* the same person, even though I was changed, and this was really exciting. Sameness and Difference had merged.

One of the most important ideas that I have learned from Eli Siegel is that one's purpose as a self and one's purpose as an actress *must* be the same. Purpose is not taught in acting schools. It should be. We actors would like to have a reason for acting which we can respect. Very often we don't know our reasons, and think if we did know them, we wouldn't like them. Actors,

like other artists, are subject to the great danger of using their art to be superior to and contemptuous of the "ordinary world," including the audiences one hopes so much to impress! Aesthetic Realism is the first body of knowledge to give an aesthetic criterion for distinguishing between good and bad purposes in art and in life.

I began to act seriously when I was about twelve. But I didn't know why I wanted to be an actress. I just had to be. I didn't like the "real" me (this is common), so I tried to escape me by being someone else. Eli Siegel told me what I heard from no acting teacher before: that I was trying to complete myself through difference. He said: "Acting shows that you don't have to be fettered to yourself. You can be other people. . . . The big question is whether acting helps you to find out who you are or to get away from who you are."

At the beginning, I used acting to get away from who I was. I wanted to play heroic parts, like Saint Joan, or poignant, wistful ones, like Emily in *Our Town*, who says: "Goodbye. Goodbye, world. Goodbye, Grover's Corners." The ordinary world for me was dull and oppressive. Also, I didn't want my family to have anything to do with my career. They were in a separate, inferior world. It was soon after graduating from Performing Arts that I began to study Aes-

thetic Realism, and I was asked questions every actor needs to be asked. My feelings about acting, good and bad, were described, criticized, clarified. I felt: This is me.

An excerpt from one of my early Aesthetic Realism lessons shows something of the change that took place in my mind:

SIEGEL. Reality has three moods: beneath, divine, and homespun. Which don't you like?

FIELDING. Homespun.

SIEGEL. I thought so. What is the homespun?

FIELDING. Reality, I guess.

SIEGEL. Homespun is the ability to see reality not as a crisis. . . . Do you think if there is no crisis, things are boring?

FIELDING. Yes. That's one reason I want to act, I think. It seems like another world.

SIEGEL. What do you see as boring?

FIELDING. Sometimes a whole day is boring.

SIEGEL. That's not specific. Things are boring because you lump them all together. Do you see an empty cotton spool as boring?

FIELDING. Yes.

SIEGEL. You say that with the full depth of your perception—that it is boring?

FIELDING. Maybe not.

SIEGEL. I'll relieve you—it's not. Do you think streets are boring?

FIELDING. Yes.

SIEGEL. And rooms, and scraps of paper, and sweater threads? Do you think the edge of this board is boring?

FIELDING. (pause) Now that I've looked at it, it isn't boring.

SIEGEL. As soon as you see a thing as individual, it's not boring. The edge of this board has opposites, for one thing, and that makes it interesting. What do you think should be between moments? . . .

And there was also this:

SIEGEL. Is a play all high points?

FIELDING. No.

SIEGEL. What's in between?

FIELDING. Homespun?

SIEGEL. Is a symphony all high points?

FIELDING. No.

SIEGEL. That's what Liberace gave you—only the high points. Your notion of drama is different from mine. Drama doesn't fight reality, it shows what reality is.

For the first time I knew why I cared for acting, and I was proud of my choice.

In his 1951 lecture on acting, Siegel says:

This possibility of loving the world that we have through acting is much worthy of study. . . . Since a

human being is a compound of *is* and *might,* a compound of what's before him and what can be imagined, in all sincerity we have an element that is like acting. Everybody wants to be himself, and that means being other things besides oneself.

A performance of recent times seen as extraordinary was Zero Mostel's in Ionesco's *Rhinoceros.* Did he become other than himself! Without makeup or costume change, Mostel literally became a rhinoceros right before the eyes of the audience. Very often, in the actor's attempt to take on a character, he will use all sorts of makeup, wigs, and accents. These can be helpful, but they sometimes obscure the real person, and then we have neither the actor nor the character.

Within and Without, Depth and Surface are in all acting. We go deeply into a part in order to come out with fullness and believability. Michael Chekhov wrote of the "psychological gesture." If you put your hand to your head, something will happen to you inside. If you extend your arms wide, something will happen inside. You can start the other way around. You can begin with a memory of something deep in your mind. In every part, however, within and without must be one.

An example of these opposites working together occurred to me when the Hamlet Revisited Company

was in rehearsal for *Shakespeare's Hamlet: Revisited*. We had come to Ophelia's mad scene, and Eli Siegel gave me a directorial suggestion which swiftly brought together Ophelia as frighteningly *in* herself, and also *out* of herself with distraction. Mr. Siegel suggested that as I came to the line of her song, "Fare thee well, my dove," I slowly extend my arm as if I were holding a small bird; then release the bird and watch it fly into the air, as though something very close to me were going far out into the world. I have played this scene many times, and that gesture never fails to cause a deep emotion within me.

In the world of acting, there is a need for a central idea which combines both technique and purpose—what Stanislavski called the "broad base." Eli Siegel's Theory of Opposites advances and gives a further dimension to all that has been learned about acting. We actors need a purpose that we can see as lastingly right.

IS BEAUTY THE
MAKING ONE OF
OPPOSITES?

and

ART AS LIFE

Is Beauty the Making One of Opposites?

ELI SIEGEL

FREEDOM AND ORDER

Does every instance of beauty in nature and beauty as the artist presents it have something unrestricted, unexpected, uncontrolled?—and does this beautiful thing in nature or beautiful thing coming from the artist's mind have, too, something accurate, sensible, logically justifiable, which can be called order?

SAMENESS AND DIFFERENCE

Does every work of art show the kinship to be found in objects and all realities?—and at the same time the subtle and tremendous difference, the drama of otherness, that one can find among the things of the world?

Is Beauty the Making One of Opposites? was originally published by the Terrain Gallery in 1955 and reprinted in the *Journal of Aesthetics and Art Criticism* the same year.

ONENESS
AND
MANYNESS

Is there in every work of art something which shows reality as one and also something which shows reality as many and diverse?—must every work of art have a simultaneous presence of oneness and manyness, unity and variety?

IMPERSONAL
AND
PERSONAL

Does every instance of art and beauty contain something which stands for the meaning of all that is, all that is true in an outside way, reality just so? —and does every instance of art and beauty also contain something which stands for the individual mind, a self which has been moved, a person seeing as original person?

UNIVERSE
AND
OBJECT

Does every work of art have a certain precision about something, a certain concentrated exactness, a quality of particular existence?—and does every work of art, nevertheless, present in some fashion the meaning of the whole universe, something suggestive of wide existence, something that has an unbounded significance beyond the particular?

LOGIC
AND
EMOTION

Is there a logic to be found in every painting and in every work of art, a design pleasurably acceptable to the intelligence, details gathered unerringly, in a coherent, rounded arrangement?—and is there that which moves a person, stirs him in no confined way, pervades him with the serenity and discontent of reality, brings emotion to him and causes it to be in him?

SIMPLICITY
AND
COMPLEXITY

Is there a simplicity in all art, a deep naiveté, an immediate self-contained-ness, accompanied perhaps by fresh directness or startling economy?—and is there that, so rich, it cannot be summed up; something subterranean and intricate counteracting and completing simplicity; the teasing complexity of reality meditated on?

CONTINUITY
AND
DISCONTINU-
ITY

Is there to be found in every work of art a certain progression, a certain indissoluble presence of relation, a design which makes for continuity?—and is there to be found, also, the discreteness, the individuality, the brokenness

of things: the principle of discontinuity?

DEPTH
AND
SURFACE

Is painting, like art itself, a presentation of the "on top", obvious, immediate?—and is it also a presentation of what is implied, deep, "below"?—and is art, consequently, an interplay of surface and sensation as "this" and depth and thought as "all that"?

REPOSE
AND
ENERGY

Is there in painting an effect which arises from the being together of repose and energy in the artist's mind? —can both repose and energy be seen in a painting's line and color, plane and volume, surface and depth, detail and composition?—and is the true effect of a good painting on the spectator one that makes at once for repose and energy, calmness and intensity, serenity and stir?

HEAVINESS
AND
LIGHTNESS

Is there in all art, and quite clearly in sculpture, the presence of what makes for lightness, release, gaiety?—and is there the presence, too, of what makes

for stability, solidity, seriousness?—is the state of mind making for art both heavier and lighter than that which is customary?

OUTLINE
AND
COLOR

Does every successful example of visual art have a oneness of outward line and interior mass and color?—does the harmony of line and color in a painting show a oneness of arrest and overflow, containing and contained, without and within?

LIGHT
AND
DARK

Does all art present the world as visible, luminous, going forth?—does art, too, present the world as dark, hidden, having a meaning which seems to be beyond ordinary perception?—and is the technical problem of light and dark in painting related to the reality question of the luminous and hidden?

GRACE
AND
SERIOUSNESS

Is there what is playful, valuably mischievous, unreined and sportive in a work of art?—and is there also what is serious, sincere, thoroughly meaning-

ful, solidly valuable?—and do grace and sportiveness, seriousness and meaningfulness, interplay and meet everywhere in the lines, shapes, figures, relations, and final import of a painting?

TRUTH
AND
IMAGINATION

Is every painting a mingling of mind justly receptive of what is before it, and of mind freely and honorably showing what it is through what mind meets? —is every painting, therefore, a oneness of what is seen as item and what is seen as possibility, of fact and appearance, the ordinary and the strange? —and are objective and subjective made one in a painting?

Foreword to *ART AS LIFE*

Seldom, if ever, have we read an essay with the impact and significance of Art As Life. *Our notes, we hope, express something of what this essay can mean to people and to artists.*

As all artists do, we express inevitably a certain conviction about the essential composition of reality. We feel that Eli Siegel's view, Aesthetic Realism, completes and furthers this conviction by showing life itself to be explained and organized on the same terms: the aesthetic oneness of opposites.

We are happy to see this essay by the author of Hot Afternoons Have Been in Montana: Poems, *reach a larger public.*

The essay can, we think, satisfy a deep desire of our contemporary world, since it makes an essential relation of personal and impersonal, of analysis and synthesis. Art As Life *is not meant metaphorically. It has the firmness of steel and the energy and speed of color.*

REGINA DIENES DOROTHY KOPPELMAN
CHAIM KOPPELMAN BARBARA LEKBERG

This essay by Eli Siegel is reprinted with its original Foreword and footnotes by four artists as published by the Terrain Gallery in 1957.

Art As Life

ELI SIEGEL

> Life of Life! thy lips enkindle.
> —Shelley, *Prometheus Unbound*

ART AND LIFE are one through composition as individuality. The way we are composed is our individuality; what we feel is an instantaneous relation among everything we have. It is this relation which is life itself. The I is a composition become a point; it is integration felt as an instant and permanently. The I seems one, but we can see there are many things in it. We say: I have memory; I have hope; I have skin; I have relatives, etc. The I goes from point or oneness to manyness. If we went from the relation among things in a painting to the things themselves, we should be doing something like going from I to the things in I.

The self is that which includes everything in it, and is the result of everything in it. It is cause and

effect at once. Relation or composition in a painting is cause and effect at once, too.[1]

A general, diffuse, various thing becomes a specific thing as life comes to be. Birth is the comprehensive become specific. Any making of many things one thing is like birth. The organization which is life is more thorough than organization we see usually. The comprehensive become specific is of a richer sort. Life is reality at its most organizing, most aesthetic. It is because we are aesthetic ourselves, that we are disposed to make art.[2] But the ego can go for organization of a worse kind, of what can be called a spurious kind. When the ego is only a container, as a bucket is of stones, organization is going on of an inferior, and, in the largest sense, of a spurious kind.[3] When a relation is seen among the stones other than what the bucket willy-nilly gives them, there can be organization of a good kind. The first kind of organization is akin to inert memory; the second kind to loving imagination.

[1] It is notable in the contemporary scene that personality as the cause of art (action painting) and the impersonal formal effect (abstract art) are seen as mutually exclusive. Siegel describes a synthesis that considers both as cause, craft and result.—R.D.

[2] —And to care for art. Sculpture, for example, affects us by showing weighty matter to be buoyant and free, definite and in motion at once. What more can we want for ourselves?—B.L.

[3] Change "ego" to *line*, and there is the definition of a line fulfilling its purpose. A line separates and joins, contains and relates. See Siegel's relation of the ego to line in *The Aesthetic Method in Self-Conflict* (Definition Press).—D.K.

When man is artist, he, as a living being, honors life truly, shows life at its utmost, by giving life to objects. The principle of form or composition is the principle of life. Ego and death are separation; the whole self and life are togetherness with difference. It is for this reason that art at its best "has life", and that life at its best "has art".

Life, as such, is art. Life is the making one of repose and motion; not just motion. Consciousness in life is the repose aspect of life. True individuality is the repose arising from the relation of a self to all it has to do with.[4] Bad individuality has in it a separation between outward action and a flat repose inwardly.

Our lives are a making one of difference and sameness. Within the I is a tremendous presence of something utterly different, something akin to everything. Art is the embodiment of this difference and sameness in ourselves.

There is the disintegration of ego and there is the disintegration of death. In the disintegration of ego, a oneness of the individual is used against the idea of diversity and otherness; in death, otherness, diversity

[4] See Rodin's *Striding Balzac*. A centrality of purpose, an axis of composition, from which details proceed and to which they return; a sense of abiding personality expressed by action inseparable from its source.—B.L.

work against individuality, making for another kind of disintegration. Integration is the utmost oneness through difference, not against difference.[5] What integration is in life, it is in art.

Life results from reality showing itself as art. In keeping with the materialist idea, life is an organization of matter; as is mind. Matter makes mind. So the question is, how does matter make mind? On what terms? The materialists say that matter is capable of indefinite organization, and when organized a certain way it is alive; can have mind. The materialist, therefore, points to the necessity of organization. Organization is composition in action.

The idealist or non-materialist is just as much for organization as the materialist is. The idealist says the organizing principle *uses* matter to show itself with; the materialist is disposed to say there was no organizing principle to be seen apart from matter. However, whether the organizing principle is in matter, or uses matter, this organizing principle is like art, is art. Whatever made an individual thing aware of itself has in it the artistic process. Artists are, because within reality is art. There is that in reality, too, which can be seen as against art: that is, the separating principle.

[5] See Donatello's *St. George*. A unity of composition, heightened through the wavering stance, the shifting diagonals; a feeling of essential pride and courage through acknowledgement of hesitation and weakness.—B.L.

In a living being, there is motion resulting from how the living being looks at itself. Life is motion resulting from a thing's being for this and not for that; it is motion with pleasure or pain as a cause.[6] It is chosen motion, chosen by an individual thing. This motion must go along with what is about the thing and the thing itself; that is, a person walking across a floor in a crowded room, must be right about the floor, the room, and himself. Wherever an action is environmentally right and individually right, we have the beginning of art. For art is the seeing of relation among objects, which, while true to reality, expresses the attitude of an individual thing, a self.

What does an artist do as he looks at objects? He finds a relation among them. This relation brings them to life. The changing of a number of objects into a composition, is the making of them one thing. And the changing of the many or general into one vivid thing, is like birth. Relation in art is the giving life to objects. From this it results that a still life can be more lively than a group of lions and zealous lion tamers. Art shows that the inanimate is alive; and that the living without relation is "dead".

The fact that art is life, in the deepest sense of the

[6] See Wölfflin's Introduction to the *Principles of Art History*, especially, ". . . every artistic conception is, of its very nature, organized according to certain notions of pleasure."—D.K.

word life, can be apprehended somewhat through statements of critics. I use Thomas Munro's *Great Pictures of Europe*.* Mr. Munro, writing of Hokusai's *Rats and Capsicum Pods*, says:

> By deft gradations in the shade of gray, and by varied outlines—sometimes sharp, sometimes ragged—it achieves a spontaneous, living quality as decoration that is lacking in the Utamaro print.

Here Mr. Munro is saying that something inanimate —"deft gradations in the shade of gray" and "varied outlines—sometimes sharp, sometimes ragged"—make for "a spontaneous, living quality". This raises the philosophic question: Did life simply show these "gradations" and "varied outlines" or did "gradations" and "varied outlines" precede life? Was there anything *so* different in the way reality is seen as life from the way a painting is seen as living? In "gradations" and "varied outlines" there are difference and sameness, that is, reality. Is life the difference and sameness of reality, a showing of it? My opinion is that art says this.

Reality is general and is individuals. Reality is the all and the anything. The all become the anything is, biologically, matter become individually life. Allness

* Brentano's, Inc., 1930.

implies oneness and everythingness. Oneness and everythingness become anything is like what happens in art. There is a oneness and everythingness which, seen together, make for anythingness, or freedom. Birth is an anythingness out of the oneness and everythingness of reality. Every painting is as unique as a birth.[7]

The fact that the word *creation* is so much used in art, points to the fact that art is seen as life itself. Creation is in life, but it is the *life* part of life: there is also the dull or dead part of life. Every living thing in a way is as alive as any other living thing, but it is clear that there is, also, more life in some living things than in others; indeed, that there is more life in a living thing at one time than at another. It is this kind of life that art goes after: that which is the affirmation, increase of life. Life goes after its own increase.[8]

Two things are present in life, have to be: organization and intensity. Organization without sufficient intensity is a lessening of life; intensity without organization is also a lessening of life. The utmost or-

[7] How relevant to that moment when work begins on a new painting. There is the still whiteness of empty canvas—it is nothing and everything. It can hold terror. One mark, one line, will set this stillness into motion, and the process of putting lines on this surface is like the beginning of life.—R.D.

[8] When an artist includes and excludes, blends and contrasts, subdues and accents, his technique is busily increasing life by simultaneously ordering and intensifying it.—C.K.

ganization making for the utmost intensity, the utmost intensity making for the utmost organization are life at its liveliest: which is art.

It follows from what I have said that a portrait of a man may be more lively than the man himself;[9] that the depiction of a landscape may make the landscape livelier; that art may make decorous peaches livelier than lightweight boxers.

The question of whether art is life has much to do with whether what is called idealism is true. Idealism, from the aesthetic point of view, can be described as that philosophy which sees the world as an embodiment of a form, or forms (and the form might, by a religious idealist, be called God). If all we see, touch, smell, hit, throw, meet arises from form, then form, as the instigator of all this material vivacity and power and diversity, is the liveliest thing there is; for the cause of life would be pure, unrestrained, not-in-the-least-sluggish life. If this is the form art is after, wants to get, does get in a way, then art, having some of the very cause of life, some of pure, unpolluted living, is livelier than life as ordinarily we see it. Art would leap over life as somewhat dull agent, or manifestation, to life itself. We do get then to what Shelley

[9] A portrait by Cezanne has life because it presents the assertion and retreat in the person through the advancing and receding qualities of color.—R.D.

calls so poignantly, fervently, Life of Life! in his *Prometheus Unbound*.

We do know that art brings life to brick and stone and earth and weeds in a back yard. What is this life? Is it only an artistic metaphor, something which people interested in art are permitted to talk about because no obvious harm is done? Or is it something more? If the abstract and the concrete, form and that which we can touch, are both reality, then life in art and life as we have it in ourselves are alike in a way that goes beyond a piquant, permissible comparison.[10]

Life at its beginning is an interaction of tightness and expansion, hardness and softness, situation and change, state and desire, rest and motion. Art shows life as it begins, as it is unblurred by psychological or sociological dulling. It is because art presents life before timid or acquisitive ego can interfere with it, that art, as life, criticizes ordinary life. The criticism of life by life is art.

Thomas Munro, in describing Duccio's *The Three Marys at the Tomb*, says:

> Further life is added by strong light-and-dark contrasts between the figures, and between various planes of the tomb and mountains.

[10] In the process of burin engraving I deal with questions of abstract form and life at once. For instance, parallel engraved lines —a study in density and space—are related to a person's sense of himself as being and not being, or something and nothing.—C.K.

So how do "strong light-and-dark contrasts" add life? Munro's words would be only interestingly metaphorical unless the situations in art have something to do with *how reality is when it becomes and is life.* Reality becomes life when, as art, reality shows itself as life. Sometimes it does this through individuals, through that artistic, creative happening which is birth. Then the living beings representing reality find art elsewhere, find it in many ways. As they find art, they find life. One large implication of art is: A thing's being related gives it life. A second large implication of art is: A human being is in a position to affirm life by seeing and affirming his relation with things; and that when he does, life is made more lively, for the art it began with is welcomed; beautifully declared.